INSPIRATIONAL

art

JOURNAL

An interactive journal for the art lover

Walter Foster

www.walterfoster.com
3 Wrigley, Suite A
Irvine, CA 92618

Printed in China.
1 3 5 7 9 10 8 6 4 2
18479

About This Journal

Engage your mind during your writing journey with the *Inspirational Art Journal*, which offers individuals respite from their busy, hectic lives. This guided journal offers interesting facts about famous artists and art movements, philosophical quotes, and dozens of thought-provoking prompts and questions designed to incite contemplation and meditation. Open pages throughout invite you to write about or draw anything that moves you. It is up to you how to use this journal—we've just laid the inspirational groundwork to help you reflect and unwind.

Take some time out to study your surroundings and appreciate the natural beauty around you. Notice the vibrant intensity of the colors in nature—flowers, trees, grass, sky, water, etc. Write down your thoughts.

"*Art is either plagiarism or revolution.*"

—Paul Gauguin

Rembrandt created hundreds of paintings, etchings, and drawings over the course of his lifetime, including roughly 50 to 60 self-portraits depicting himself at various stages of his life.

Describe a moment when you captured your feelings, emotions, or thoughts in a tangible way, such as in a piece of art or photograph.

"The artist is not a
different kind of person,
but every person is a different kind of artist."
—Eric Gill

- *What does it take for a person to be a true artist?*
- *Would you consider yourself an artist? Why or why not?*

Terribilita *is a somewhat fluid term that refers to the artistic expression of discernable intensity that both inspires and induces fear.*

Describe how something beautiful can also be terrifying and vice versa.

• *Have you ever experienced the sensation of* terribilita *when looking at a work of art?*
If so, what was it and why do you think it caused you to feel the way you did?

"*All art is quite useless.*"

—*Oscar Wilde*, The Picture of Dorian Gray, *Preface*

- *Should all art strive to fulfill a certain purpose? If so, what should be its goal?*
- *Is the creation of art, per se, a noble ambition?*

Romanticism was a complex, emotional movement that prized the intuitive and poetic side of the individual life.

The Romantics embraced the expressive power of art, nature, and the sublime. Describe a time when you have been awed by something in nature or a magnificent work of art.

"Things are only worth what you make them worth."

—Molière

The Impressionists sought to capture brief moments in time. Explore the world outside and try to capture your response to nature in just a few words.

"Everything has its *beauty*,
but not everyone sees it."

—Confucius

- How much of beauty is relative to individual experience, and how much is the same for everyone?

- How is beauty different from goodness? Can thoughts and actions be beautiful?

"For as long as I can remember
I have suffered from a deep feeling of anxiety,
which I have tried to express
in my art." —Edvard Munch

"The world is but a canvas to the imagination."

—Henry David Thoreau

- *Where do the invaluable mental powers of creativity and imagination come from? The mind? The brain? Evolution? God?*
- *How is imagination involved in experiences of art?*

Write about a time when something unpleasant, ugly, or unsettling moved you to enact a change in your life, career, or circumstances.

At a time when art depicted religious subjects with reverence and veneration, artist Caravaggio depicted subjects more genuinely, which meant showing the less favorable reality of the often unsightly, sometimes dirty human form.

"But what if man had eyes to see the true beauty—the divine beauty, I mean, pure and clear and unalloyed, not clogged with the pollutions of mortality and all the colors and vanities of human life...?" —Plato, Symposium, 212

- Is any work of art ever perfectly beautiful, or is it always flawed in some way?
- Are the five senses capable of receiving universal truths about our world?

"Painting is such torture!
And I am no good at all."

—Monet, in a letter to Gustave Caillebotte, September 4, 1887.

Describe a personal experience when you judged yourself more harshly than the situation called for.

"...generally art partly completes what nature cannot bring to a finish, and partly imitates her."

—*Aristotle*, Ethics; Book II, pt. 8

- *Has an experience of art ever inspired you to change your character or behavior?*

- *Should all art strive to reflect universal truths about human life?*

"I myself am Surrealism." —Salvador Dalí

Write about your last strange or interesting dream, or a dream that left a profound impact on you. Try to capture on paper what you remember in as much detail as possible.

"I paint self-portraits because
I am the person I know best."
—Frida Kahlo

- *What do you think is the benefit of depicting traumatic or painful experiences in art?*

"*Beautiful art* must look like nature, although we are conscious of it as art." —*Kant* (Critique of Judgment, 45)

- *In what ways are reason and sensory perception both necessary in the appreciation of art?*
- *Can you think of a piece of art that is beautiful in a way you can't put into words?*

"For me a picture...should be something likeable, joyous, and pretty... there are enough ugly things in life for us not to add to them."

—Pierre-Auguste Renoir

Write about what you feel has been the most beautiful and
pleasant experience of your life so far.

"Art...is a means of union among men, joining them together in the same feelings, and indispensable for the life and progress toward well-being of individuals and of humanity."

—Leo Tolstoy, What is Art? Chapter V

- *Do people spend too much time and energy focusing on art, neglecting more important matters?*
- *Is it enough to receive pleasure from art, or should art also foster a loving spirit?*

*• Do you believe
that our world is too
focused on reason
and control?*

"With eyes strengthened and refreshed by *the sight of the Greeks,* let us look upon the highest spheres of the world around us."

—Nietzsche, The Birth of Tragedy, 15

The human body
is one of the most
popular subjects in the
history of art. Whether
it's being mimicked,
idealized, or
deconstructed, it is a
perennial fascination
of artists and art
lovers alike.

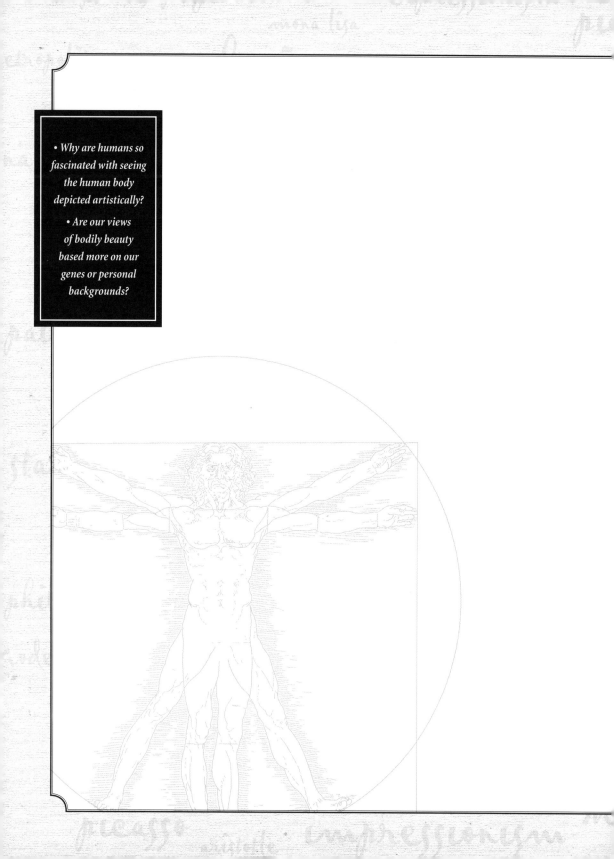

- *Why are humans so fascinated with seeing the human body depicted artistically?*

- *Are our views of bodily beauty based more on our genes or personal backgrounds?*

"*A morning-glory at my window satisfies me more than the metaphysics of books.*"

—Walt Whitman

• *Why do you think the natural world is so often referenced in art?*

• *Why do humans feel so moved and inspired by nature?*

Write about a time when creativity helped you find relief
or clarity during hardship.

"...Sometimes I wonder
 how all those who do not write, compose or paint
can manage to escape the madness, the melancholia,
 the panic fear which is inherent in the human condition."
 —Graham Greene

- *When you look at a piece of artwork, do you analyze its objective reality or just your subjective experience of it?*

- *Is all of reality relative to experience, or are there certain truths that are the same for everyone? If so, what are they?*

" *Reality is merely an illusion,*
albeit a very persistent one."
—Albert Einstein

"Language is the blood of the soul
into which thoughts run and
out of which they grow."

—Oliver Wendell Holmes

- *How has art been used in politics for both virtuous and corrupt ends?*

- *What kinds of art, if any, should be censored by political leaders?*

"Art is always and everywhere
the secret confession,
and at the same time the immortal movement of its time."
—Karl Marx

"Success is dangerous. One starts to copy oneself and copying oneself is more dangerous than copying others. This leads to sterility."

— Pablo Picasso

- *How difficult is it to stay original and continue creating new and unique work?*
- *How does one avoid becoming sterile?*